Sacred Geometry

UNSPOKEN PROMISES

A NATURAL
SOURCE OF
HEALING

This EXPERIENCE belongs to:

©2015 Art-Unplugged

Design by Dana Wedman

This book is not intended to as a substitute for the advice of a mental-health-care provider. The publisher encourages taking personal responsibility for your own mental, physical, and spiritual well-being.

Correspondence concerning this book may be directed to the publisher, at the address above.

Look for the entire series of art-unplugged journals.

ISBN: 1940899079 (Sacred Geometry)

Printed in the United States of America

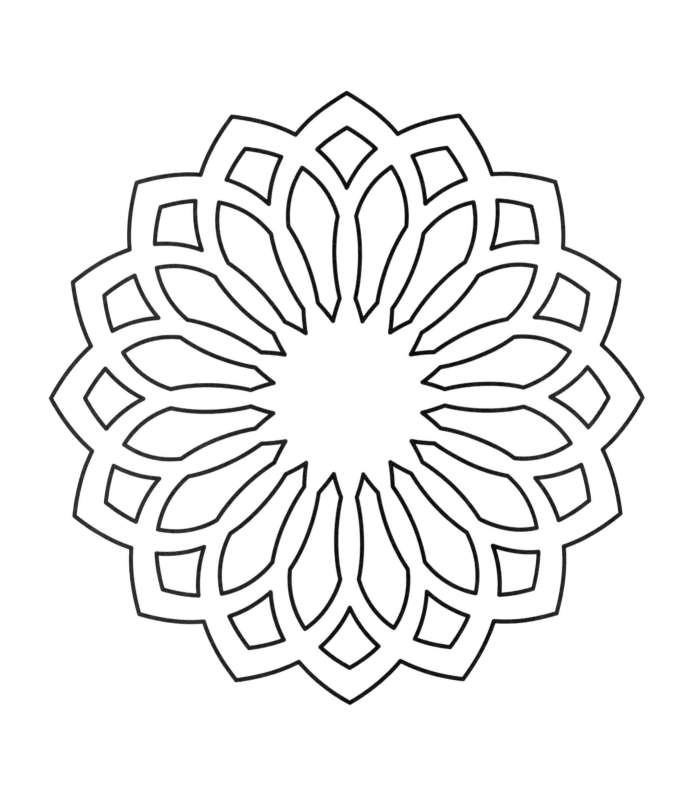

Sometimes people interpret the word sacred as "blessed." Think and journal about the blessings in your life.

Do you like to color by yourself or with friends? What is better about coloring in the company of others? What is better about coloring alone? Knowing what makes each experience special can help you take better care of yourself.

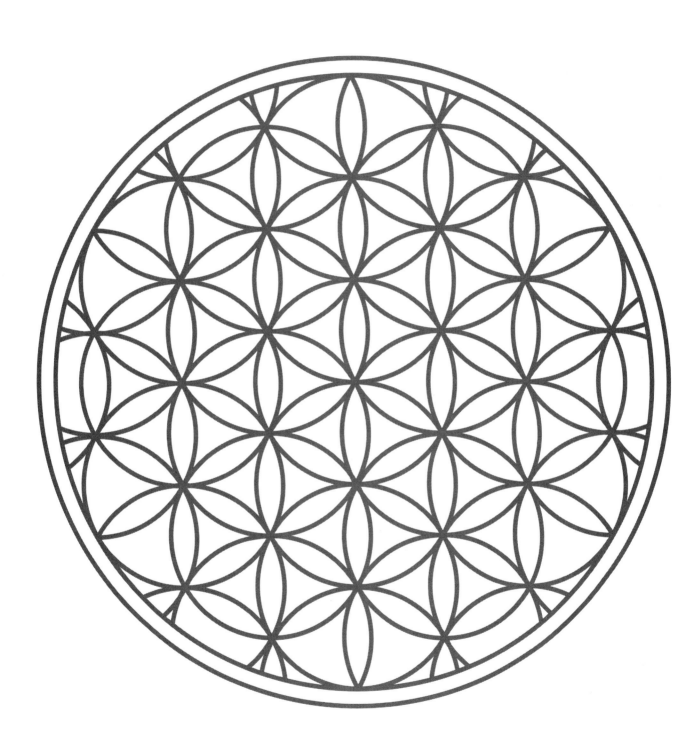

The word sacred *is often defined as "set apart for something special." You have set aside this time to color and reflect. Think about this time as special. Now write about what is special about you taking time for yourself.*

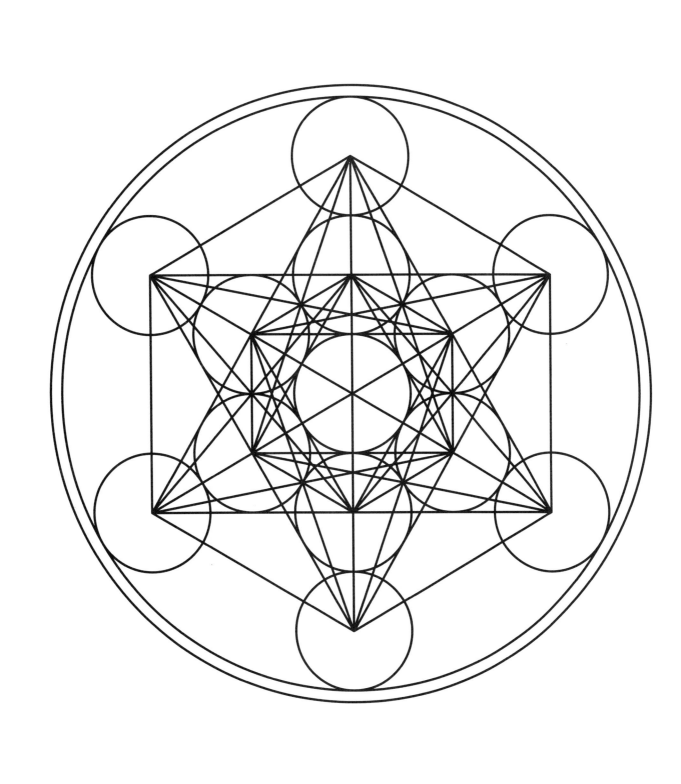

What are some names you could give this picture?

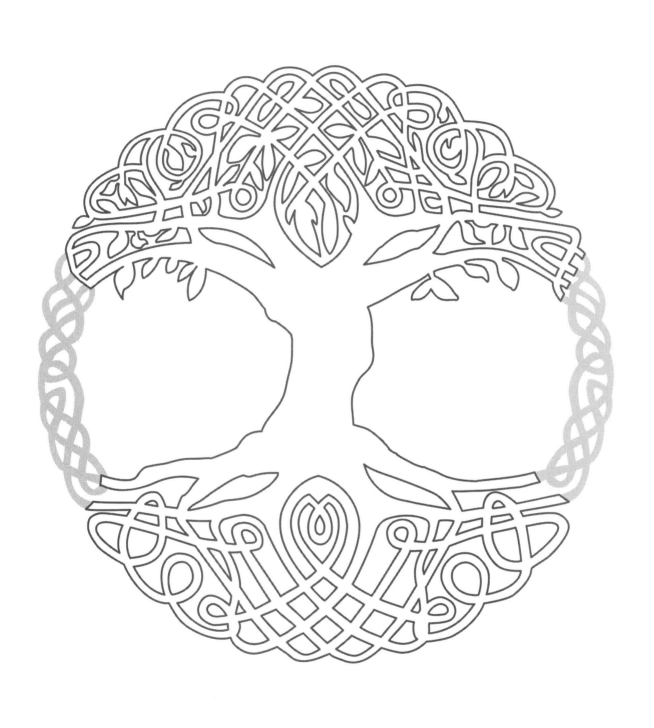

Does this picture remind you of anything in your life? Think about a time when you saw or read about this image.

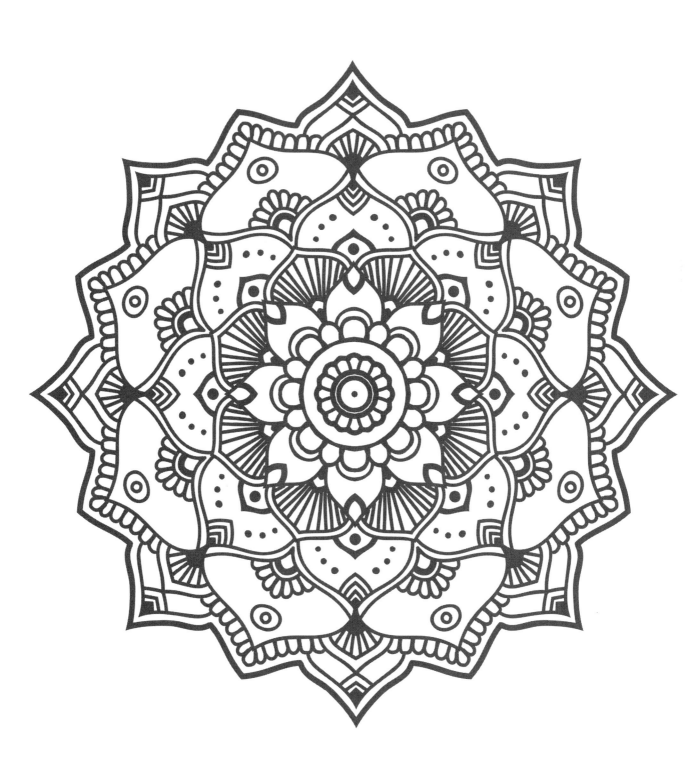

Sacred geometry is an ancient concept that reminds us how patterns seen all around can give us a sense of divine order and balance. After you color the images on these pages, think about places where you find patterns in your life that give you the feeling of order and balance. What and where are they? Perhaps your home decor, the architecture of your church, the flowers or plants in your yard, the sound of music. . . .

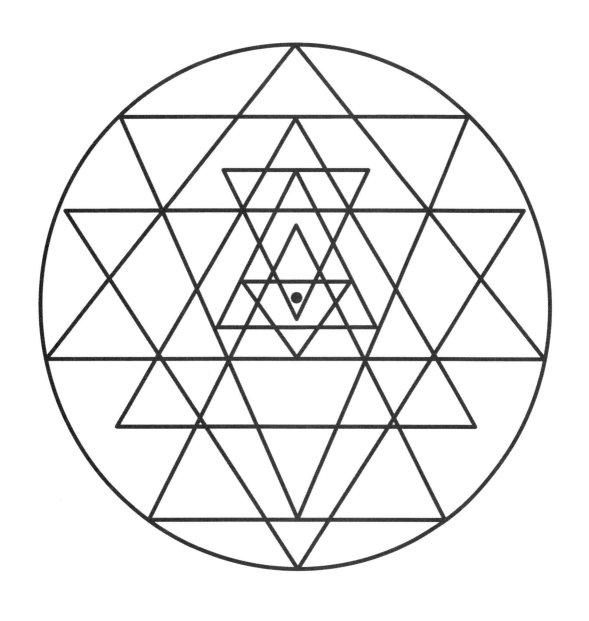

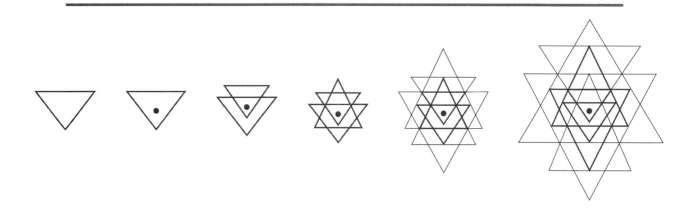

Therapy is from the original word for healing. How does Art Therapy heal your stress and anxiety?

Sacred geometry seeks to communicate truth in its stability and calm. Do these images that you are coloring remind you of places and spaces that are uncomplicated in your life? What are they?

Imagine a life without worry. Hard to imagine, isn't it! How does worry damage your life? Write about this. Are there any benefits to worrying? Describe some.

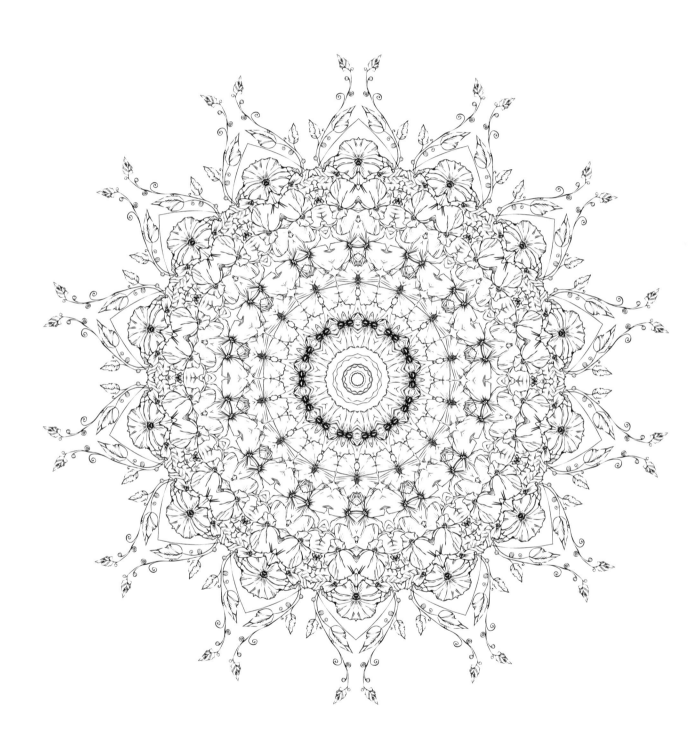

The purpose of sacred geometry is to encourage peace and tranquility through images that create clarity. Write about the patterns you see in plants, stars, and architecture that create tranquility through their predictability and repetition.

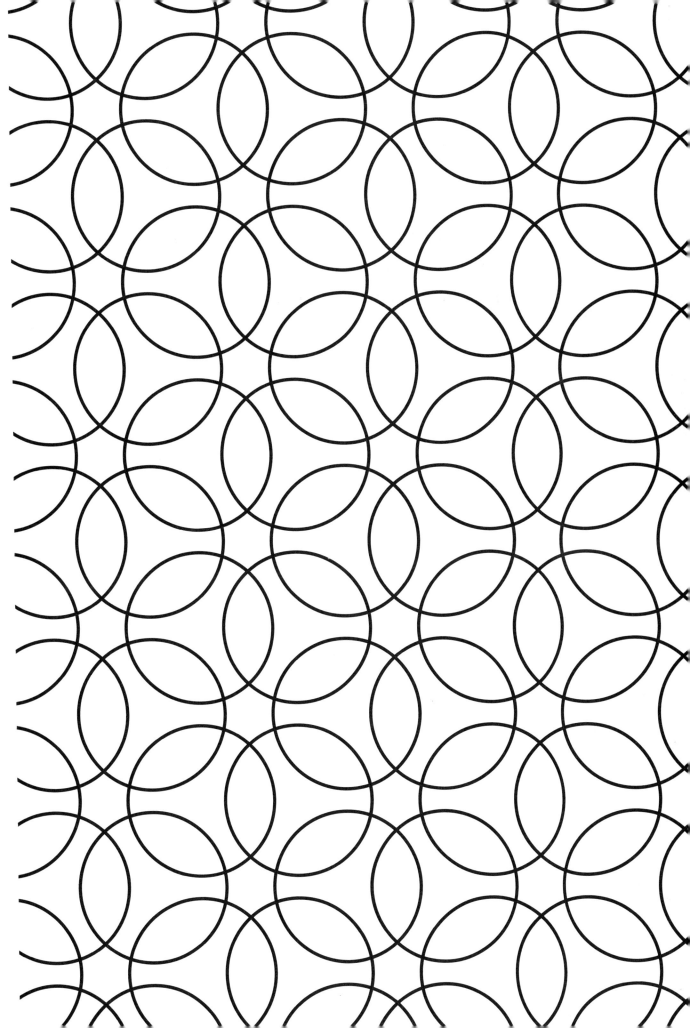

When you work with colored pencils you aren't easily able to erase your work. If you have to live with your choices, how can you turn what you think is a mistake into a new masterpiece? How is this like the rest of your life? How can you turn mistakes into magic?

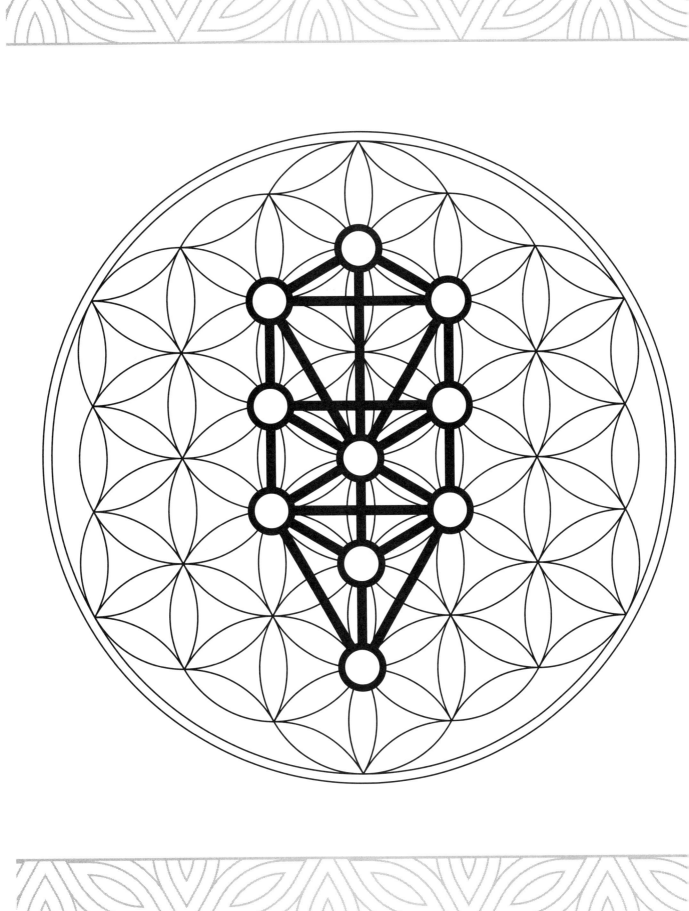

Even your own body exemplifies a kind of sacred geometry. Write about the symmetry in your body that you have come to count on for stability and harmony. Can you see any reminders in the image you just colored of how you need your body's symmetry for balance?

Where is your favorite place to color?
What do you like about this place, and what
makes it special? If you don't have a favorite
place to color, imagine creating a kind of art
studio that would bring out the best in you.
What would it look like?

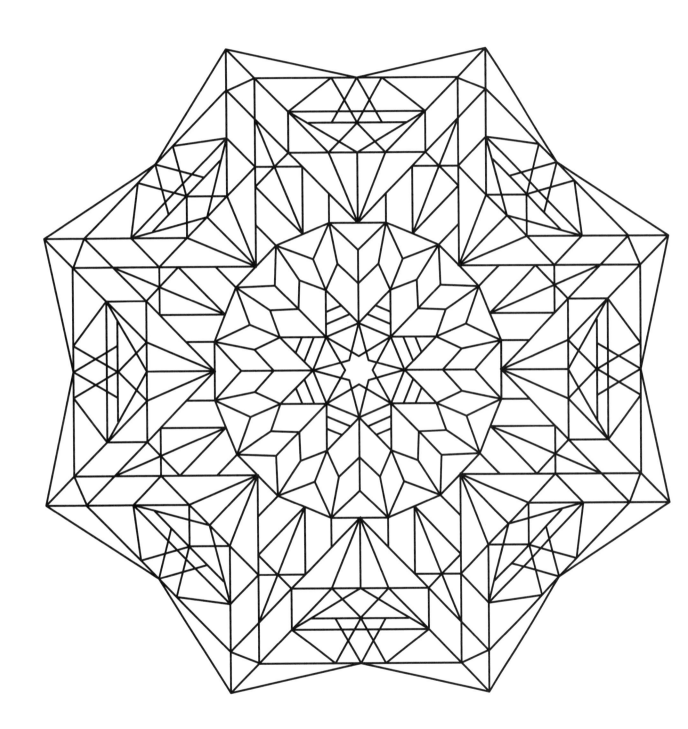

We find sacredness in all kinds of places—not just the obvious places but also in spaces within our hearts and souls. Write about how you tap into your soul's sacredness. What helps you remember that you are sacred and set apart for something special?

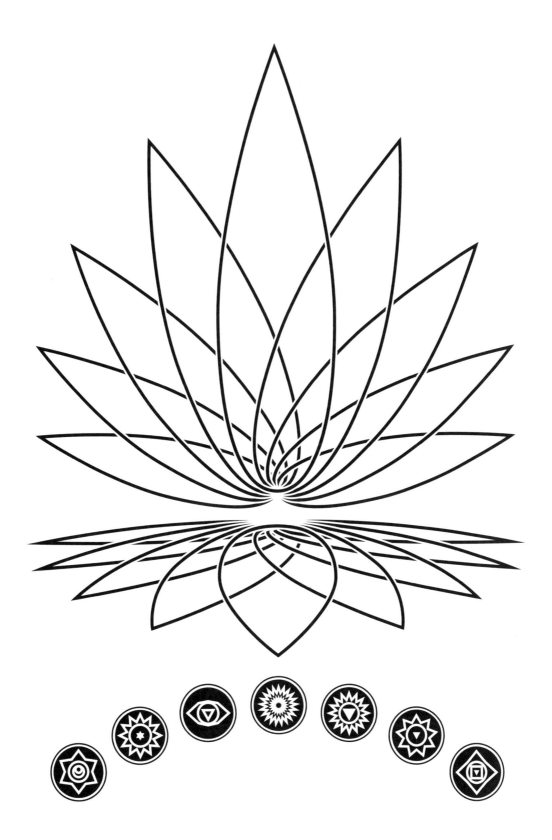

When you reflect on this picture, think about what you hope for in life. What are your hopes for today?

Early geometry was concerned about spatial relationships. As you color these images, think and write about the important relationships you have with others. Who is important to you that you feel close to? Who is important to you that you feel distant from? How can you become closer to those you want?

How does coloring these small spaces create a sense of importance in your life?

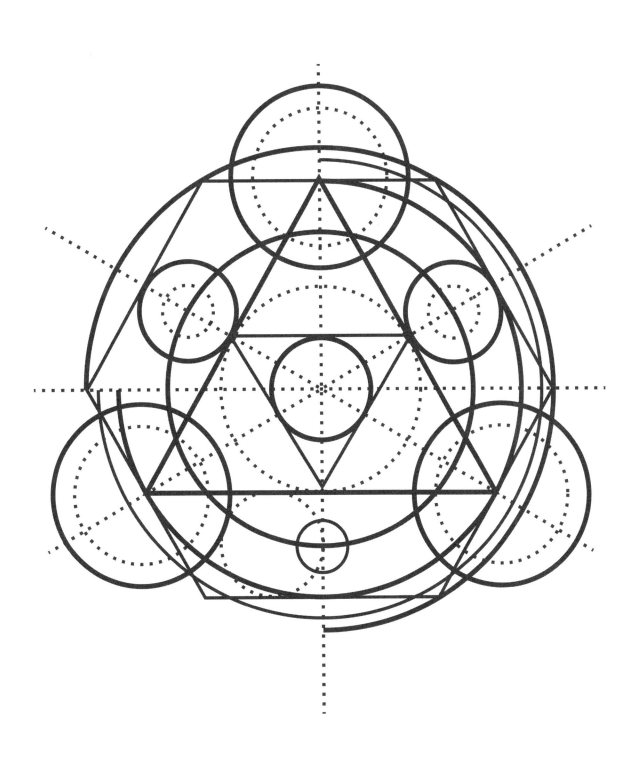

Sometimes being able to predict future events or feelings gives comfort and calm. Does coloring the predictable patterns on these pages help you feel calmer? What else in your life is predictable? What seems unpredictable and out of control in your life? Write about how much you need predictability and certainty in your life and why.

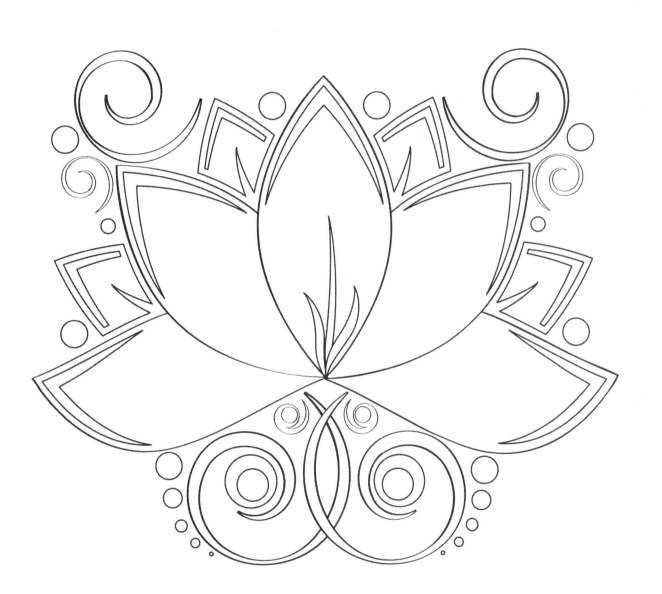

How does this picture inspire you to be your best? How do you define the word best? Can your best be different from someone else's best? Why does this matter?

Sacred geometry seeks clarity in physical, emotional, and spiritual relationships. Where do you experience the most clarity in your life?

Does coloring calm you and comfort you?
Describe other practices that make you
feel calm.

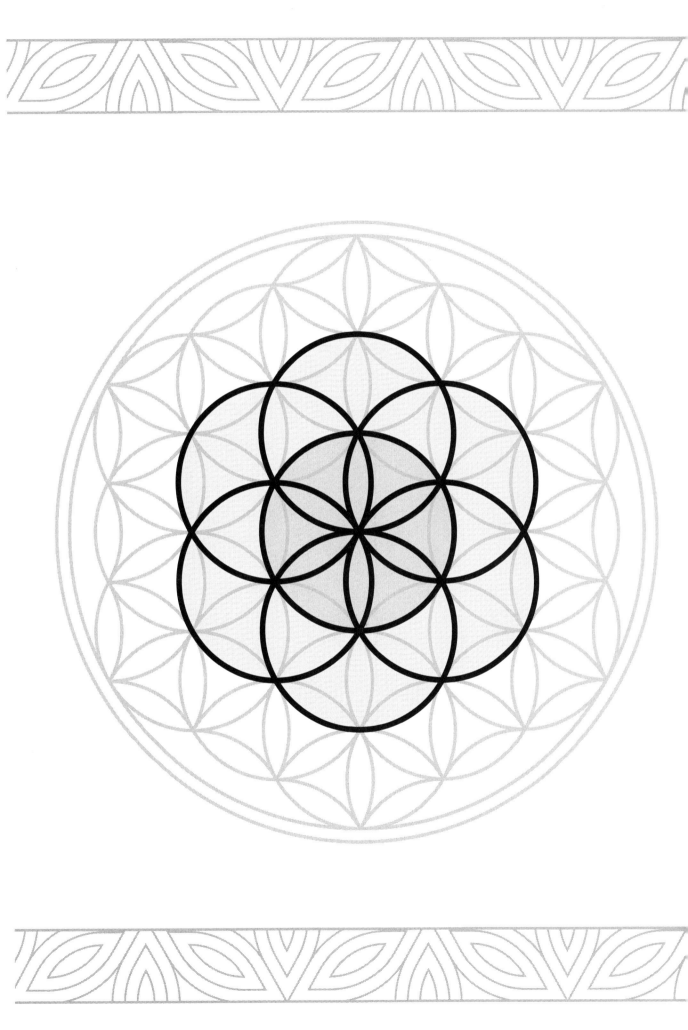

As you color, tap into your feeling of purpose. What else gives you a sense of purpose in life?

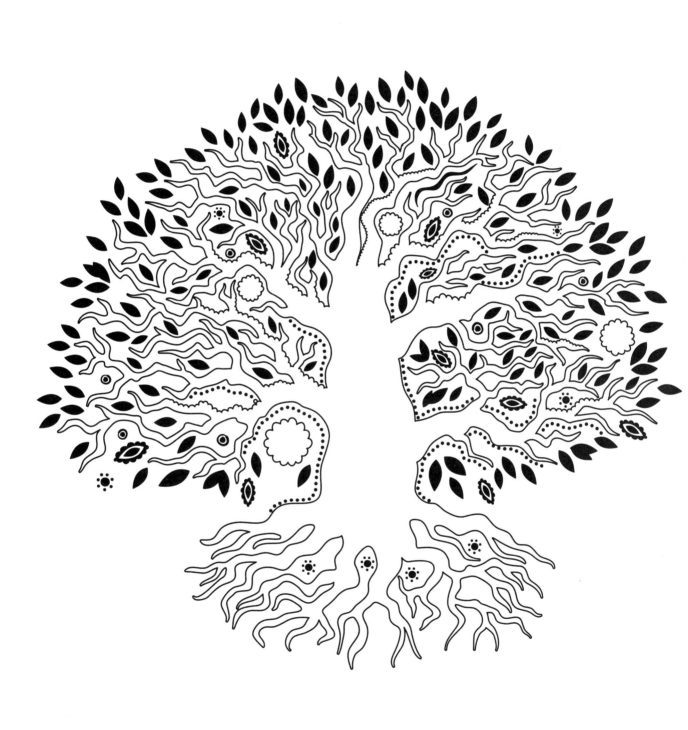

As you color these pages, do your troubles and frustrations melt away? If or when they return, do they seem less troubling and more manageable? Can you get a different perspective on them when you take a break by coloring?

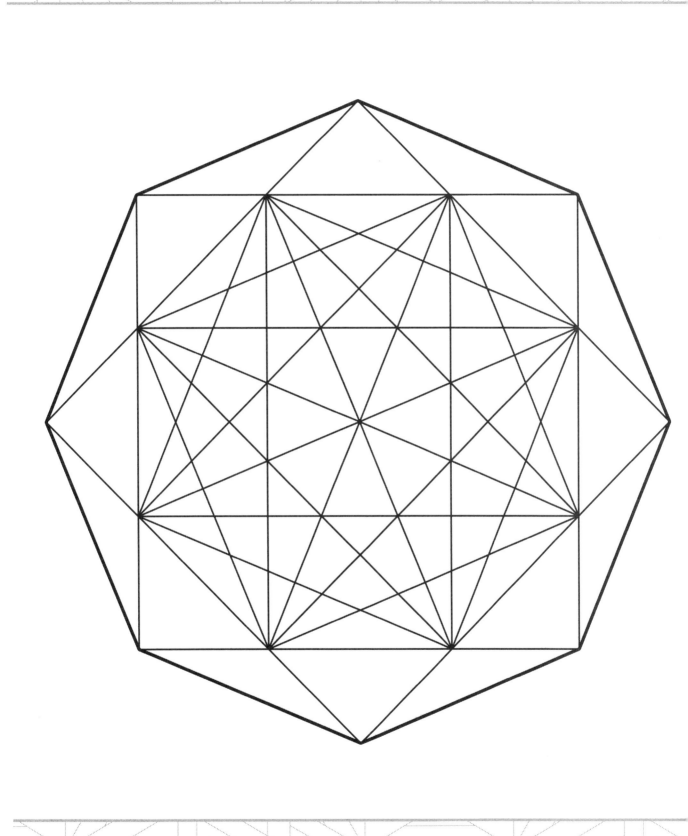

There is natural significance all around us, from the honeycombs that bees create to the repetitive petals of the lotus flower. Write about plant life and other natural forms all around you that can remind you of the natural order of life, as opposed to man-made order. What do you think brings you more assurance? Natural or man-made forms?

Sacred geometry has relevance to music because there are musical ratios, octaves, and harmonies that manifest mathematical truths and order. What kind of music creates balance and harmony for you when you listen to it? Write about the type of beat you like to listen to and why.

Certainty can encourage faith. As you color these images, focus on the confidence your faith gives you. Write about your faith and what is predictable about it versus unpredictable.

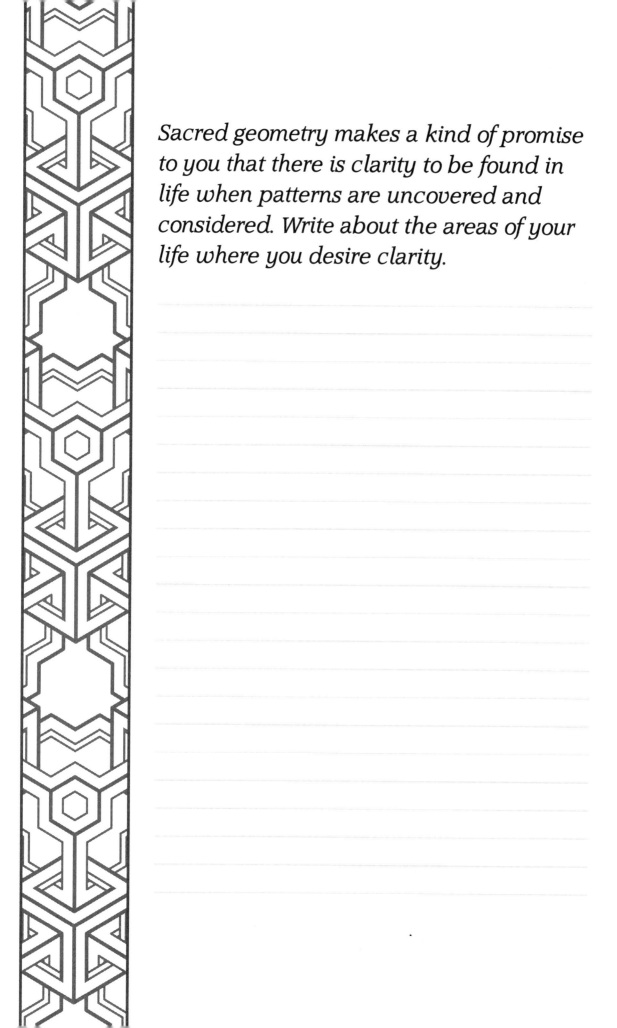

Sacred geometry makes a kind of promise to you that there is clarity to be found in life when patterns are uncovered and considered. Write about the areas of your life where you desire clarity.

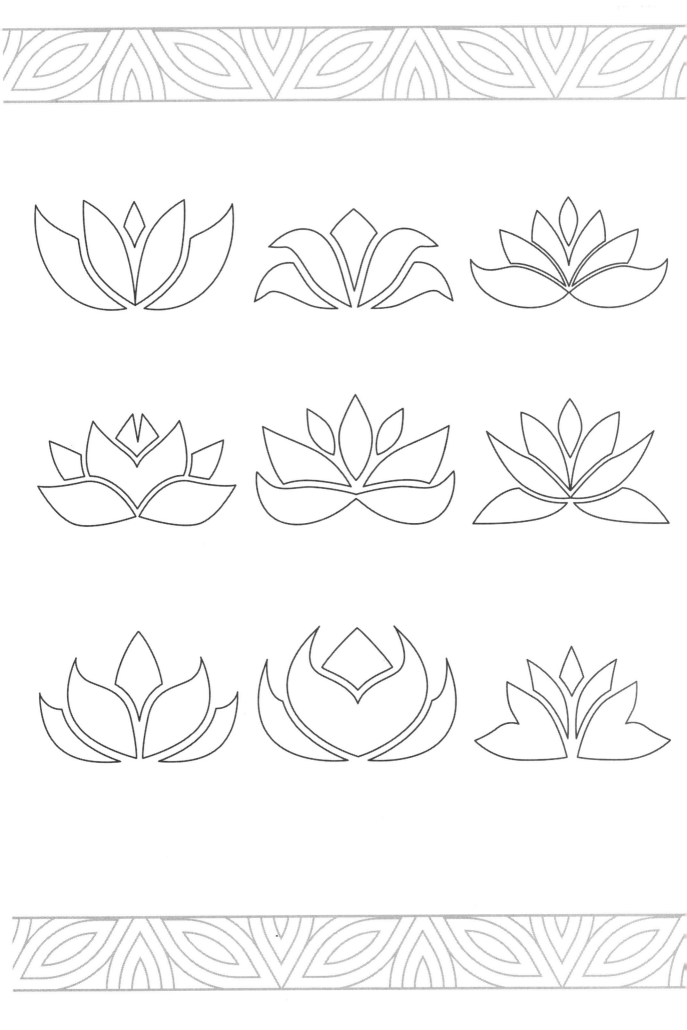

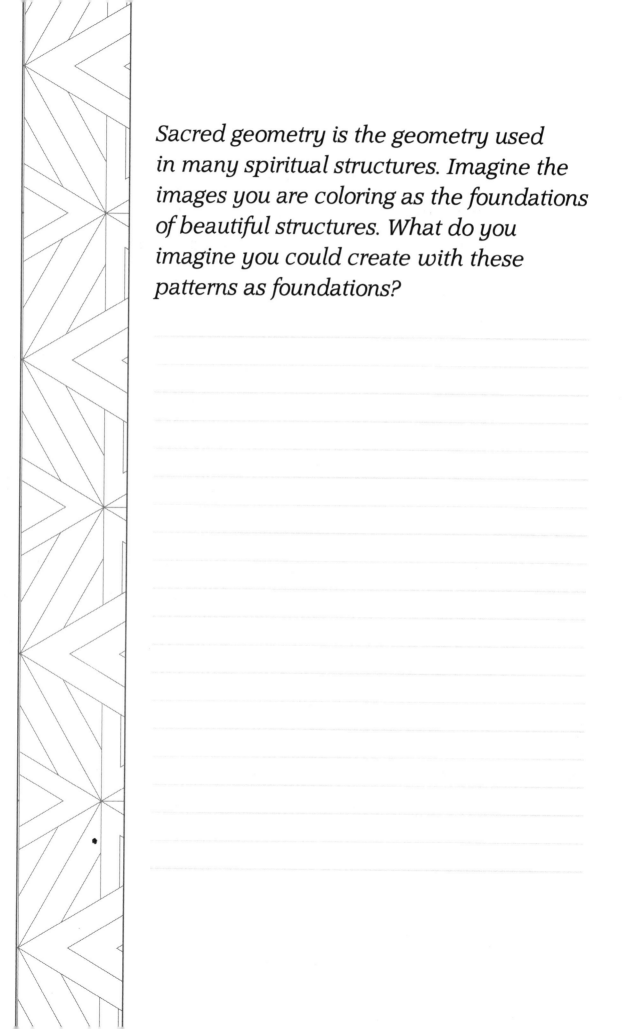

Sacred geometry is the geometry used in many spiritual structures. Imagine the images you are coloring as the foundations of beautiful structures. What do you imagine you could create with these patterns as foundations?

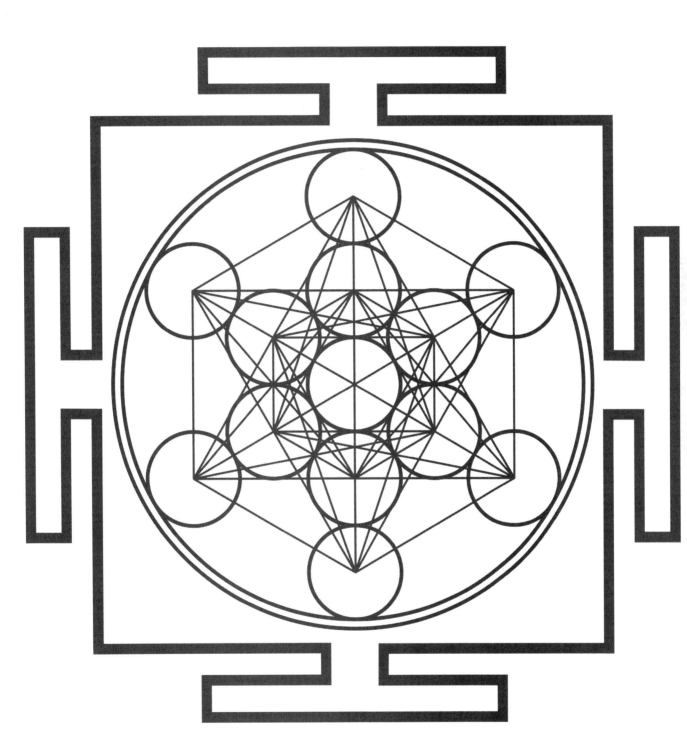

What colors do you gravitate toward in your artwork? How do different colors make you feel? Does the color red stir up different feelings in you than the color blue? Which colors make you feel calmer? Can you surround yourself with more of this color? How and where?

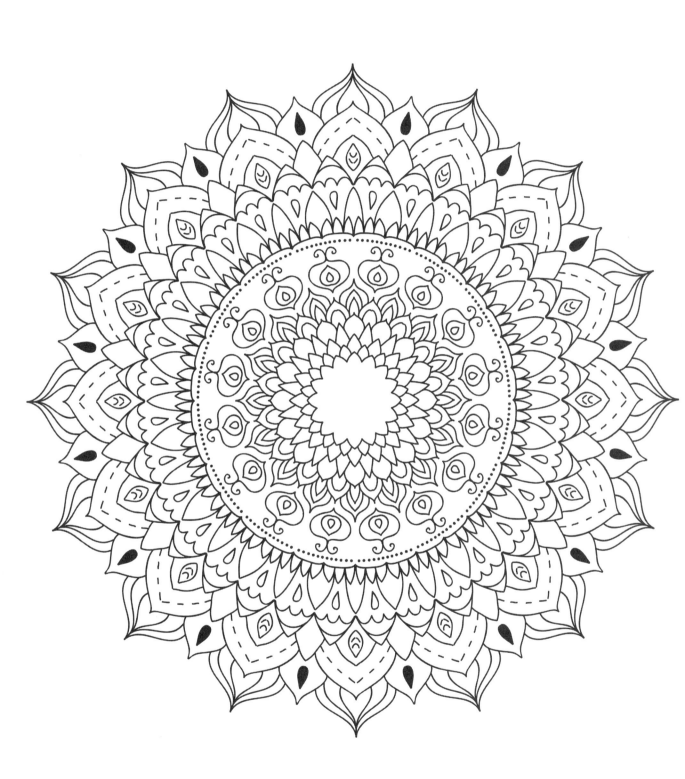

Sometimes patterns remind you of places or activities from your past. What do these images remind you of? Are these happy memories? Do the patterns affirm the harmony and balance possible in your life?

Do you find yourself coloring more when you are happy, or stressed? Bored, or nervous? How does coloring help you? How does coloring distract you? Do you consider it a good way to channel your energy?